IMAGES OF AMERICA

ERIE
PENNSYLVANIA

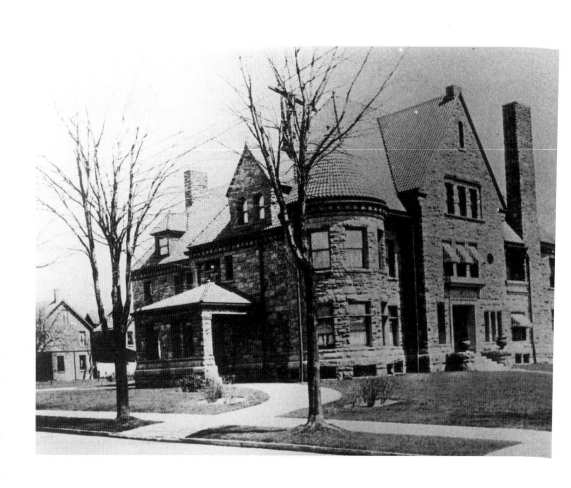

IMAGES OF AMERICA

ERIE
PENSYLVANIA

JEFFREY R. NELSON

ARCADIA

This book is dedicated to Kenneth Pfirman, head
archivist at the Erie Historical Museum and Planetarium.
Ken is an ardent proponent of the city of Erie's history.
He has touched others and brought them to knowledge,
giving them a gift greater than treasure.

Frontispiece: The Erie Historical museum and Planetarium.

First published 1998
Re-issued 2003

Published by Arcadia Publishing
an imprint of Tempus Publishing Inc.
Charleston SC, Chicago, Portsmouth NH,
San Francisco

Printed in Great Britain

Library of Congress Catalog Card Number: 2003106988

For all general information contact Arcadia Publishing at:
Telephone 843-853-2070
Fax 843-853-0044
E-mail sales@arcadiapublishing.com
For customer service and orders:
Toll-Free 1-888-313-2665

Visit us on the internet at http://www.arcadiapublishing.com

Contents

Acknowledgments

The preparation and production of a work such as this encompasses the assistance of many individuals. Special thanks is extended to Laurie McCarthy of the Erie Historical Museum and Planetarium, head archivist Kenneth Pfirman, and Nancy Kenerson Brown. Without the support of the Erie Historical Museum and Erie Mayor Joyce Savocchio this book would not have been possible. I would further like to thank the archives of the Erie Metropolitan Transit Authority, the Diocese of Erie, the East Erie Turners, the Firefighters Historical Museum, and Mr. Paul Morabito, Jim Zollner, and Joe Weindorf. Our heartiest thanks to the residents of Erie, who shared their personal treasures with us. I also wish to thank my wife, Fay, my daughter Jaimeleigh, and my father, Robert Nelson, who assisted in the composition of the book. I ask that the reader understand that this book is more a celebration of our community's past than an orthodox history. Erie's history is expansive, and there honestly was not sufficient space to cover all groups or places of interest.

Introduction

Erie is best described as a municipality of contrast. In sum and substance it is a large metropolitan city that possesses the semblance of a small village containing the history of a nation. Today, it's hard to imagine our city as a frontier settlement in 1795, in what was then Native American territory. The name Erie comes from the Erie Nation, a non-aligned Iroquoian-speaking people. They lived here in peace until the Great Beaver War from 1653 to 1657. During this war the Erie Nation was crushed by Seneca and Mohawk warriors of the Iroquois Confederacy. The Europeans called our area Presque Isle. French coureurs de bois used Presque Isle as a place to trap and trade furs. In 1753 Coureur Marin was sent to Presque Isle to build a fort and settlement. By 1757 it was home to 356 citizens and allies of New France.

The military importance of Presque Isle (Erie) cannot be overstated. Retaining the natural harbor and relatively agreeable portage to the Ohio region made this a logistically significant district. The French lost the region in 1761 to the English, who constructed a blockhouse and garrisoned Presque Isle. It was at this point that Erie developed into a truly American outpost garrisoned by troops of the Royal American regiment containing men from the American colonies. In June of 1763 a pitched battle was fought at Presque Isle between these troops and First Nation people following Delaware Chief Pontiac. During this three-day battle the garrison was forced to surrender, though a few lucky survivors escaped to Detroit. The Presque Isle region remained part of England's colonial holdings until after the American Revolution. Captain Bissell of the U.S. Army constructed a blockhouse and garrisoned Presque Isle again in 1795. General Anthony Wayne concluded a peace with the First Nation people that same year. While travelling down Lake Erie the general became sick and died at the Presque Isle blockhouse on December 15, 1796. The War of 1812 brought our district once again into historic prominence as Erie was Commodore O.H. Perry's home port and the site of the construction of the United States Naval Squadron on Lake Erie. In 1844 the United States Navy's first iron warship, the *Michigan*, was

assembled and launched at Erie. Our port's history of naval service became so significant that Erie was called "the mother-in-law of the United States Navy."

The Pennsylvania settlement of Presque Isle is referred to as the Erie Triangle purchase. The Pennsylvania Legislature was approached in 1785 by numerous Philadelphia businessmen who wished to secure a port on the Great Lakes for Pennsylvania. The natural harbor at Presque Isle located within the Erie Triangle was perfect, but there were some significant land issues. The Triangle was outside Pennsylvania land boundaries and was claimed by New York, Virginia, Connecticut, and Massachusetts. These issues combined with the First Nation title claims and the protracted Native American conflicts in the western territories would hinder settlement of Erie until 1795.

In April of 1795, the township of Presque Isle was established by the Pennsylvania Legislature with Erie as its principal borough. The seat of county government would be 122 miles south at Pittsburgh in Allegheny County. The actual settlement of Erie began in July 1795, with settlers arriving first by way of the lake. Seth Reed and his family are recorded as the first permanent settlers of Erie. They opened the first business in the community, the Presque Isle Hotel. The city was planned and designed by Andrew Ellicott and General William Irvine.

Difficulties encountered by these settlers were numerous. Erie was then a solitary place far away from other settlements. In 1800, the Commonwealth of Pennsylvania created the county of Erie with the county seat at our city. Development at this point had been delayed. The particular location and lack of accessible assets had earmarked Erie as "the sleepy little borough."

Transformation came quickly in 1806 when the salt trade arrived at Erie by way of the waterfront. In the westward movement of our nation, salt was a scarce and important commodity. The port of Erie soon became a consequential link in the movement of this valuable commodity. Salt trade instituted the needed capital to stimulate growth in the community. This precipitated the expansion of roads and population which introduced stage service with Buffalo and Cleveland. Construction of the Erie Extension Canal in the 1840s and the railroad in the late 1850s yielded further evolution. No longer a "sleepy little borough," industry and commerce permitted Erie Borough to incorporation in 1851 as the City of Erie .

Expansions in transportation, commerce, port operations, and entrepreneurial opportunity attracted new immigrant American citizens to Erie. Throughout the nineteenth century our city continued to increase in size. At the dawning of the twentieth century, it could be said without hesitation that Erie is the ideal American hometown. Immigrants from many nations have discovered the allure and opportunity of America in Erie. Ethnic diversity has always been one of Erie's greatest strengths. This diversity and strength has given Erie an extraordinary resource—the citizens of Erie. The people of our community are its driving force through adversity and prosperity. They have given a unique cultural heritage and history to our hometown village. In understanding the struggle of our shared past in Erie, we will forge the renaissance of our city into the twenty-first century.

one

The Resplendent Erie

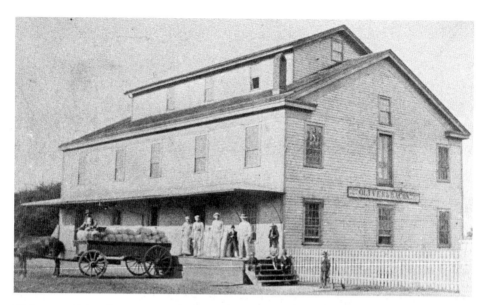

Welcome to Erie. The year is 1868, and the Oliver and Bacon Mill is using surplus water from the Beaver Extension Canal for power to produce flour and grist. It was located on the west side (or Jerusalem section) of Erie between 5th and 6th on Myrtle. The city had come a long way since Seth Reed arrived here in 1795 and was at the threshold of industrial expansion. The rudimentary structures were giving way to a resplendent nineteenth-century American industrial metropolis. (EHM&P Collection.)

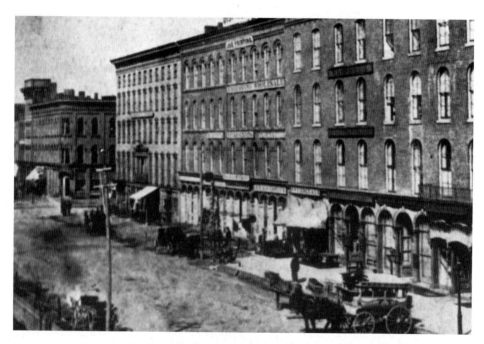

Looking north from the Reed Block between 5th and 6th on French Street, with the Dispatch printing and newspaper building in the center of the block. Erie was losing its pioneer appearance rapidly. (Nelson Collection.)

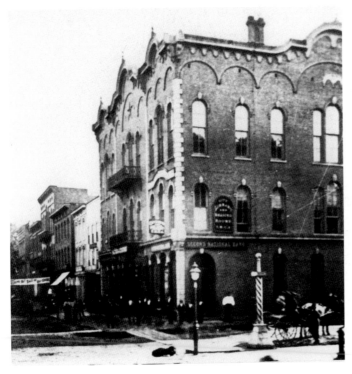

Erie was fast becoming a banking and mercantile center at 8th and State Street. This is the Second National Bank building. The Irving Literary Society had rooms on the second floor housing our city library collection. This society operated a library until 1867, when the YMCA became trustee of the collection. (Nelson Collection.)

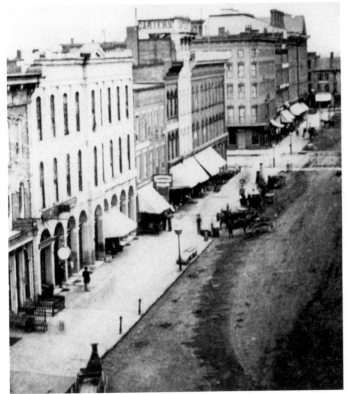

An address of importance in American pharmacology. It was here, at 21 North Park Row, that one of the first pharmaceutical manufacturers was founded in the nineteenth century. The patented medicine business was just beginning to take hold in America when Dr. J.S. Carter entered into the field. His first patented medical cures were "Carter's Little Liver Pill's" and "Carter's Smart Weed." The products were received with acclaim by the American public and Carter's name became nationally recognized in commercial pharmaceuticals. (Nelson Collection.)

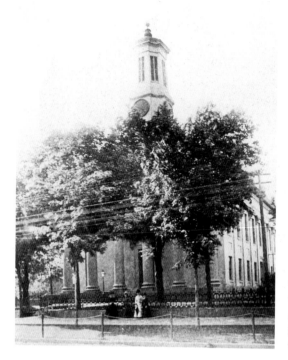

The Erie County Court House located on West 6th Street, constructed between 1852 and 1855 at a cost of $60,000. It is seen here in a late 1860s photograph with its clock tower. (Nelson Collection.)

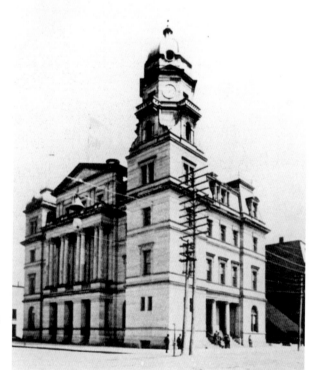

The new federal building at State and South Park, constructed between 1882 and 1887 at a cost of $250,000. This building was the first official home to Erie's post office. (Nelson Collection.)

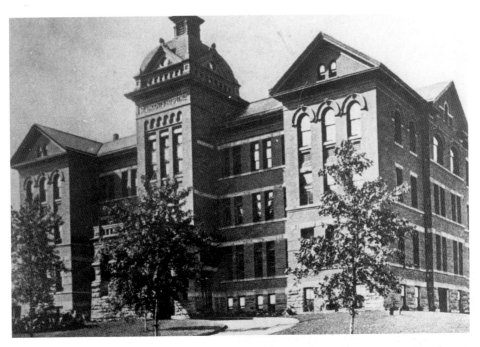

Erie's first hospital, opened in 1875 through the efforts of the Catholic Sisters of Saint Joseph. This is Saint Vincent Hospital on West 24th and Sassafras on the grounds of the old Catholic cemetery. (Nelson Collection.)

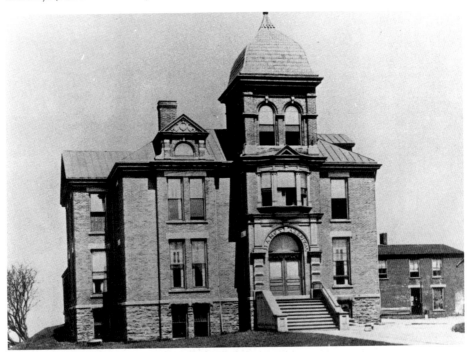

Hamot Hospital, located on the high bluff at the foot of State Street over looking the harbor. The building was opened as a hospital in 1881. (Nelson Collection.)

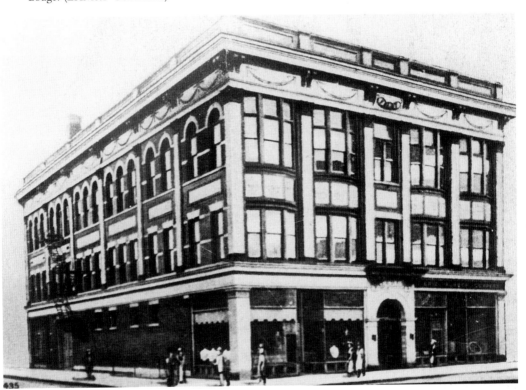

Right: Erie's German-American community's Maennerchor Music Hall Society, organized in 1872. This clubhouse was built in 1896 and contained a fully equipped theater. (EHM&P Collection.)

Below: The Odd Fellows fraternal organization of Erie, formed in 1846. There were a number of lodges throughout the city. In 1908 this hall was constructed at 11th and Peach by the Lake Shore Lodge. (EHM&P Collection.)

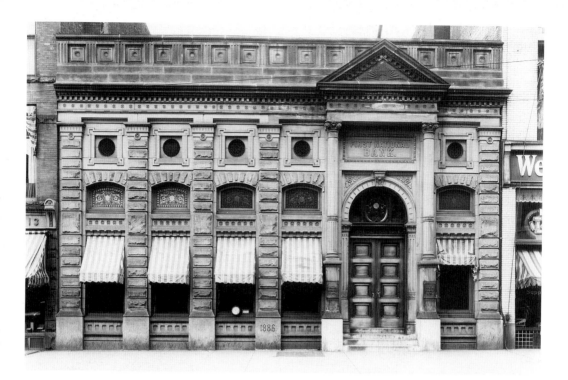

The First National Bank at 715 State Street, photographed around 1910. The area surrounding 7th to 10th on State has always been a major banking center. (Nelson Collection.)

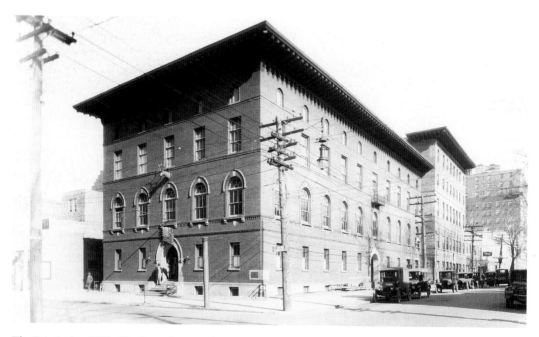

The Erie Lodge, BPO Elks, located on at 8th and Peach on the northwest corner. The lodge was formed in 1887 and boasted many prominent Erie business men among its members. (Nelson Collection.)

The Young Gladiators of Erie

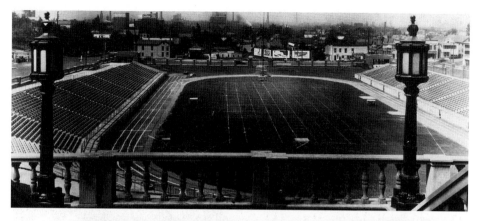

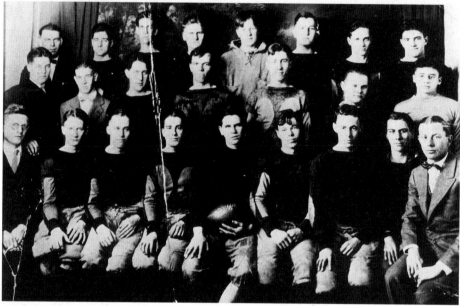

Top: Erie's Veterans Stadium has been the stage for many contests between Erie's athletes. Our community has a strong interest in sports and supports many amateur and semi-professional sports clubs, though we achieve superlative satisfaction from the young men and women athletes of our local schools. This 1927 photograph looks north over the field and toward the city. (Nelson Collection.)

Above: The Central team of 1926. These members are, from left to right, as follows: (front row) Shanor, A. Weindorf, R. Curtiss, H. Randolph, T. Doyle, S. Holcomb, A. Hamm, Connell, and Coach Fletcher; (middle row) A. Glough, T. Lehan, R. Cobney, R. Fuller, M. Rowley, M. Woodward, and F. Shaffer; (back row) J. Hyde, String Nash, J. Small, E. Jageman, J. Harper, F. Baushard, C. Hern, and H. Doyle. (Joe Weindorf Family.)

Opposite, top: The Erie Central High School football team, photographed in 1927. The snow is typical of an Erie fall. (EHM&P Collection.)

Opposite, middle: Father Tully and the boys of the Saint Andrew's parish football team. This photograph hails from either 1901 or 1905 and shows the uniforms of the time. (Joe Weindorf Family.)

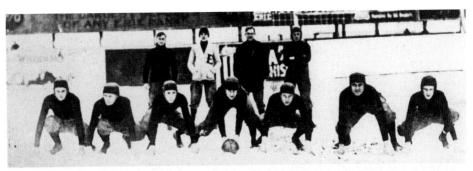

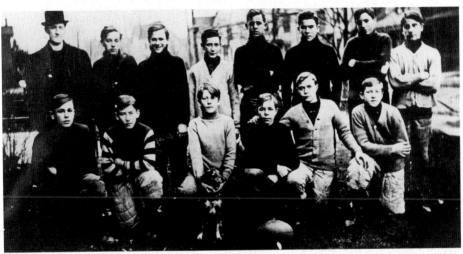

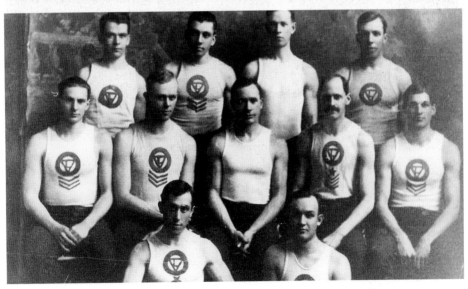

Above: The YMCA Leader Squad of 1912. From left to right are as follows: (front row) Peter Erhart and Anthony Loeslin; (middle row) Donald Lloyd, Carl Schacht, Dr. Evans, Frank Bixby, and Harry Adams; (back row) Clyde Langdon, Clarence Mook, Chester Loden, and Presley McCreary. (Zollner Family Photo.)

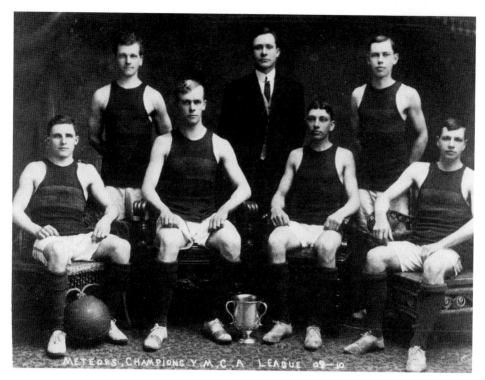

The 1909–10 YMCA. From left to right are as follows: (front row) James Allburn, Carl Schacht, Clarence Mook, and Leon "Barney" Mook; (back row) J. Mook, Dr. Evans, and Carl Obert. (Jim Zollner Family.)

Coach Ed Weindorf and the Triangles Basketball team, Erie City champs in 1918. Buz and Joe Weindorf Sr. were members of this team. (Joe Weindorf Family.)

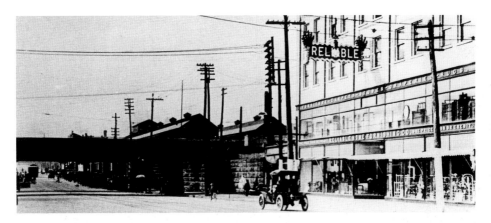

A surprise around every corner. Arriving at 14th and State Street we see the Reliable Furniture Store. Here we can buy new items for our home and on credit. It would seem that we have walked right out of the business district. Erie is full of surprises—there is one around the corner.

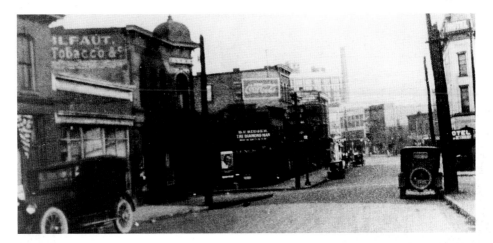

The city to the north. After turning at the southern end of Turnpike we encounter the B.F. Sieger Jewelry store. Here we can have our watch fixed or buy some fine jewelry. Afterward we can stop next door for something to eat.

Moving across to 14th and Peach Streets. Here we find a common sight to people in Erie—the street is closed.

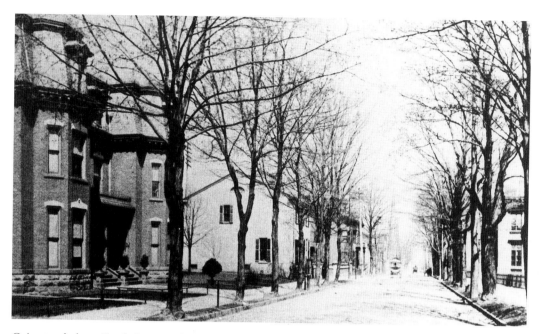

Going north down Peach Street to the neighborhood of 8th and Peach. These are the homes of C.H. Strong and D.D. Tracy.

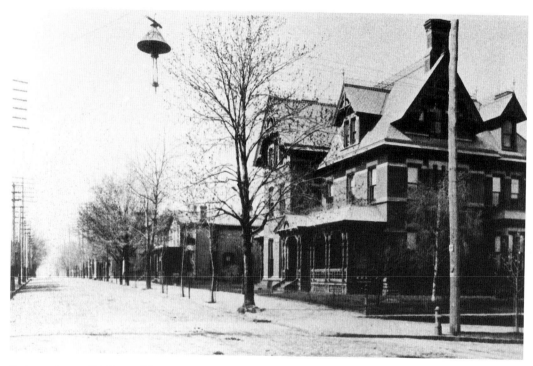

Going east on to 9th Street. There are many well-kept homes lining both sides of the street. Arriving at the corner of 9th and French we look north at the home of Charles Jarecki.

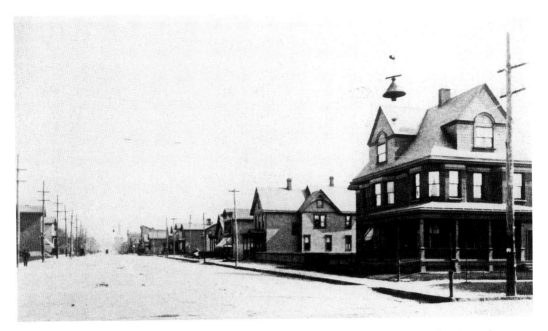

Traveling down French Street to 6th Street and proceeding east to Parade Street. This view, taken looking south up Parade Street, shows another of Erie's business sections.

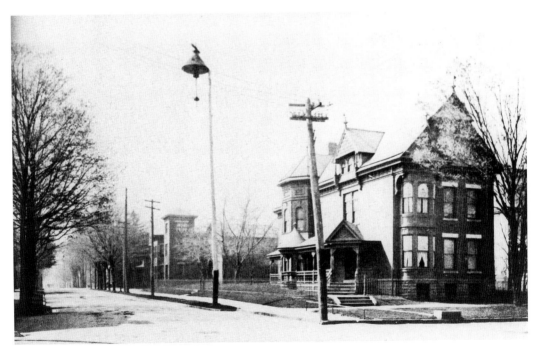

West on 6th Street. In the mood to walk more than shop, we go west on 6th Street until arriving at the corner of Sassafras. We decide to go up Sassafras, continuing our walk of Erie.

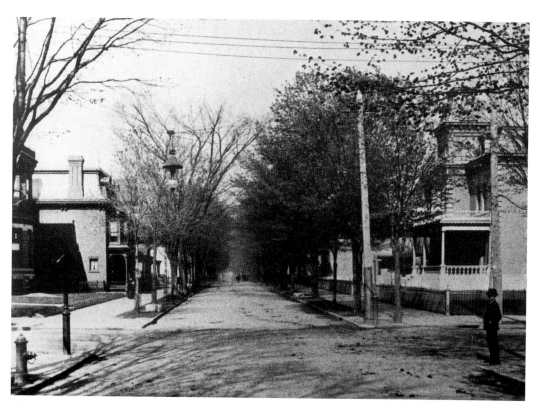

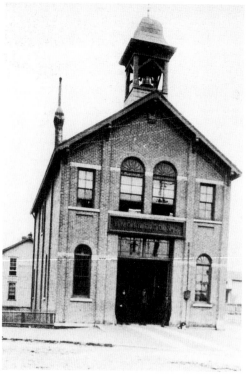

Above: Traveling up Sassafras to 9th Street. Let's go east over 9th to Peach. Walking towards Peach, the home of C.F. Adams is on the left; Joe McCanter's residence is to the right. Once at Peach Street we decide to walk south on Peach and enjoy the fine day.

Left: The southern most limits of the city at 26th and Peach. It's been a fine day for walking. Let's go in to Engine Company Number 7 and ask when the next trolley is due for downtown.

four

Erie's Greatest
Resource

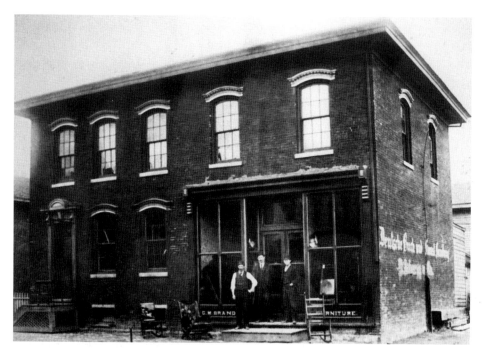

Erie's greatest resource—its citizens. The city of Erie embraces a diverse mix of world cultures and customs. At first glance separated and singular, each avenue combines to form Erie's unique resource. This area on East 11th Street, known as "Beyond the Rhine" in the 1880s, featured Charles Brandt's Boarding House, Saloon, and Furniture shop. (EHM&P Collection.)

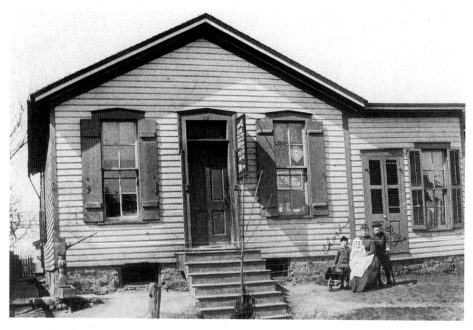

A turn-of-the-century photograph showing a typical working-class home on East Avenue with a small family business serving the neighborhood. (EHM&P Collection.)

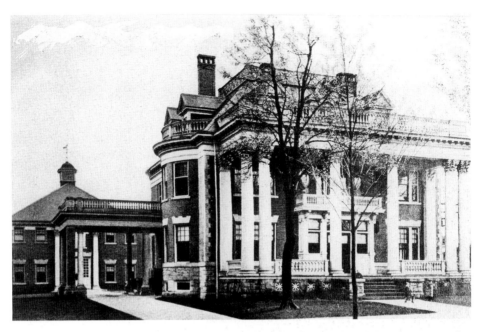

The home of J.C. Siegal on "Millionaires Row," West 6th Street. Stature and permanence in the world of commerce is exhibited in this structure. J.C. Siegal was one of Erie's prominent industrialists, bankers, and investors during the nineteenth century. (EHM&P Collection.)

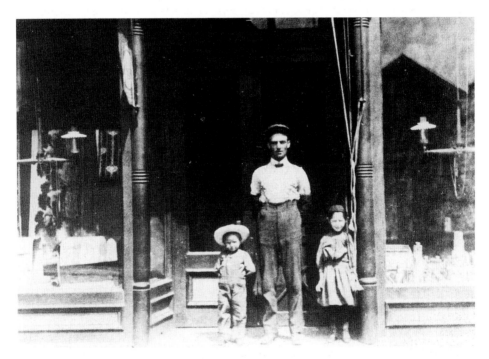

Joseph Schwab with his children in front of their family paint and wallpaper business located at 426 West 18th Street in 1903. Erie offered the opportunity to obtain a better life. Many of our citizens opened new businesses. (Schwab Family Photo.)

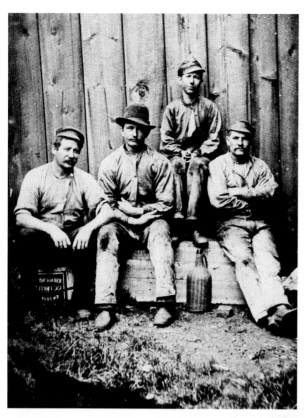

Left: Immigrant laborers at the turn of the century. Immigrants brought their skills to every conceivable type of industry. The also brought pride and determination to their new home in Erie. (EHM&P Collection.)

Below, left: Little Jack Zollner, looking like a Cowboy, on the back of a photographer's pony on East 9th Street. The traveling photographer and his pony were a common sight on the streets of "Old Erie." (Jim Zollner Family.)

Below, right: A brother and sister in their Sunday best at the turn of the century. It's apparent that the young boy would much rather be exploring the alleys of his Ash Street neighborhood than having his picture taken. (Antimouse Donation.)

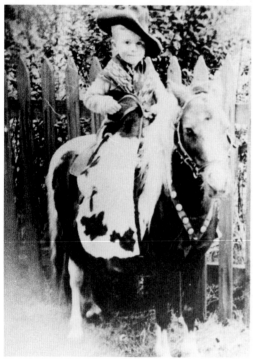

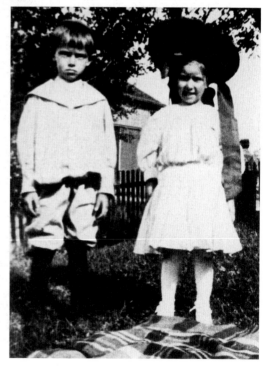

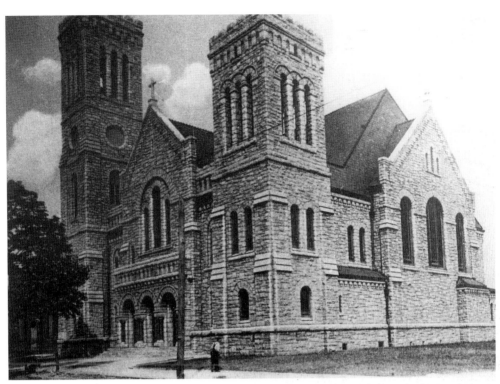

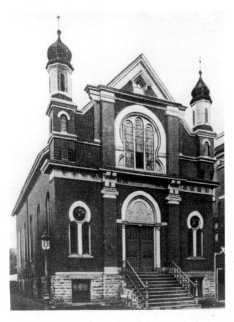

Above, left: The temple Anshe Chesed Reform Congregation, one of two temples serving Erie's Jewish community. This temple was constructed in 1882 west of Sassafras Street. (EHM&P Collection.)

Above, right: Saint Michael's Roman Catholic Church, located on West 17th Street, in 1885. This church was one of several serving the German-Italian-American Catholic community. (Nelson Family Photo.)

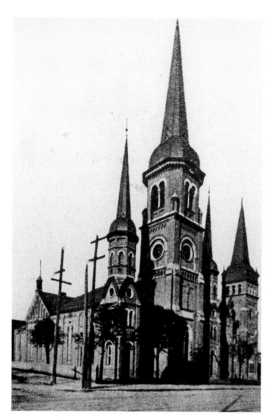

Saint John's Evangelical Lutheran Church, located at 23rd and Peach Streets in the 1890s. This was known as the German Lutheran Church, and was one of the largest in the country during the 1890s.

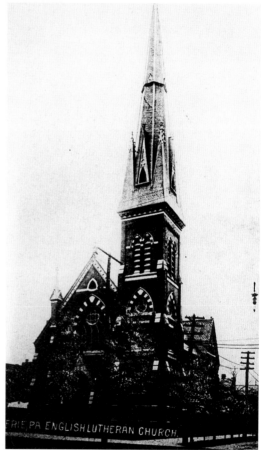

The First English Lutheran Church, located at 11th and Peach Streets in 1887. The church was founded in 1861; this structure was built in 1887. (Nelson Archives.)

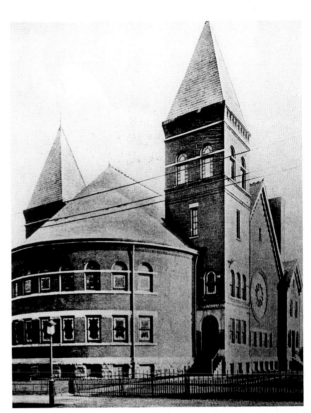

The First United Presbyterian Church, located between French and Holland on 11th Street in the 1880s. The construction of this church building was started in 1859 but it wasn't completed until 1862. (EHM&P Collection.)

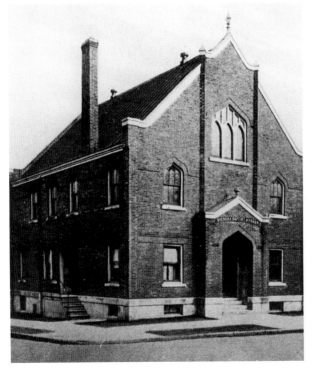

The Swedish Baptist Church, organized in 1895 located at 7th and Holland. This church was built 1906 to serve the Swedish American community. (EHM&P Collection.)

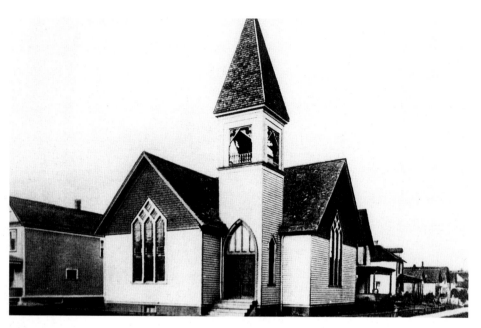

Saint Matthew's Lutheran Church at 7th and Cascade was organized in 1904. This structure was built shortly after to meet the changing population, and demographics of Erie during the 1900's. (Nelson Archives.)

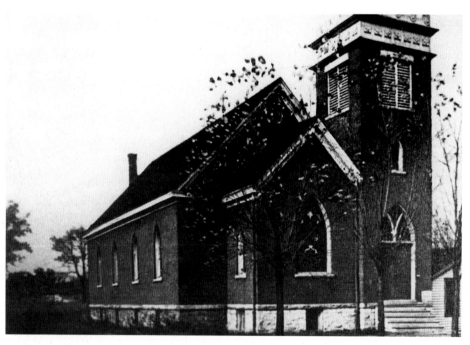

The Saint James African Methodist Episcopal Church, located at 7th and German in 1898. This church, under the Reverend F.D. Scott, served the African-American community of Erie. (EHM&P Collection.)

Going to School in Erie

High School
Erie Pa
October 15 88
Seniors - 89 -

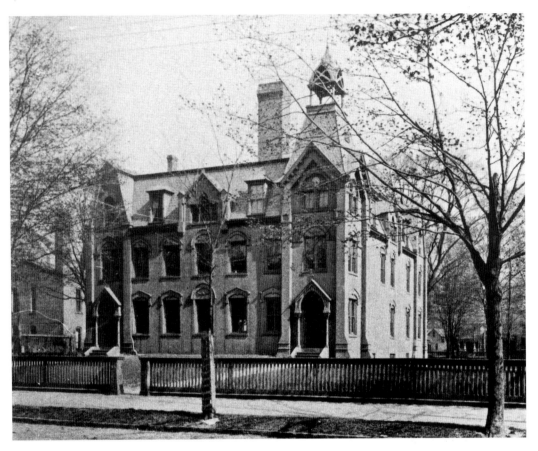

The Erie Academy in the 1880s. Education has always been an important part of our community. Our school system dates to 1805, when the Presque Isle Academy was founded by Daniel Dobbins. The Erie Academy, founded in 1817 at 9th and Peach, was our first chartered educational institution. The school housed students from kindergarten to high school. A subscription fee was charged for books. (EHM&P Collection.)

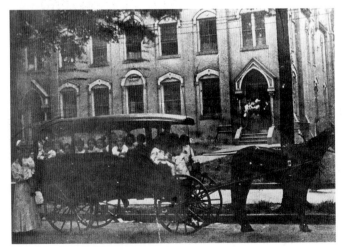

Left: Transportation to school in the late 1860s. This horse-drawn school bus gave kindergarten and primary-grade students a ride to school at the Erie Academy. (EMP&P Collection.)

Opposite, above: Henry S. Jones Public School Number 2 at 7th and Holland. This was one of the most modern schools in Erie during the late nineteenth century. The class pictured here is the fourth-grade class of 1888. (EHM&P Collection.)

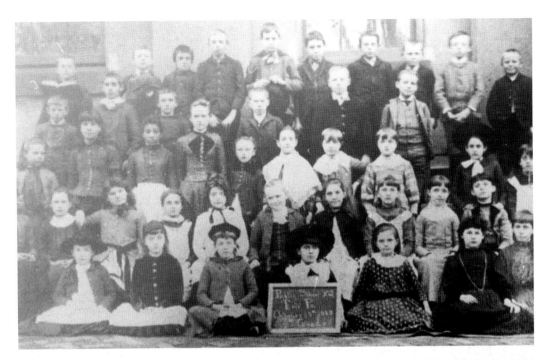

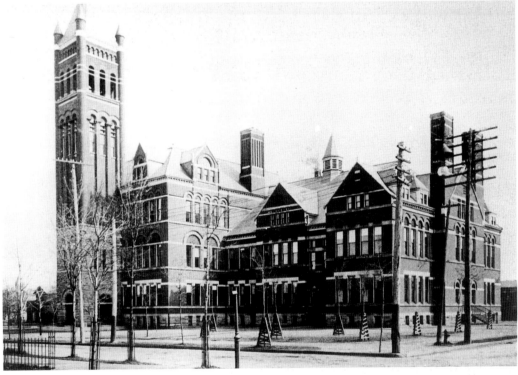

Central School at 11th and Sassafras. Opened in 1890 as a high school and junior college, the school was later used for primary through high school classes due to the need for available classrooms in Erie. In the 1930s the school was renamed Erie Technical High School. (EHM&P Collection.)

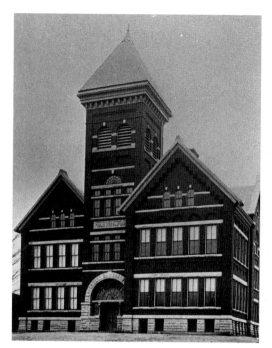

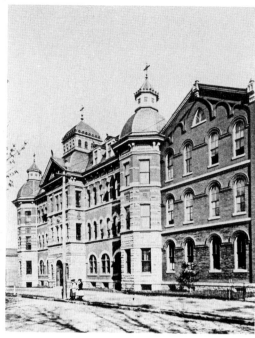

Above, left: The Franklin School, Public School Number 9, built in 1891 at 27th and Peach. This modern school had eight rooms and could seat 396 students. One special feature was a basketball court on the third floor. (Nelson Archive.)

Above, right: Saint Benedict Academy and convent at 300 East 9th Street in the 1880s. This school for young women of primary through high school years was part of the Roman Catholic Diocese of the Erie school system. (EHM&P Collection.)

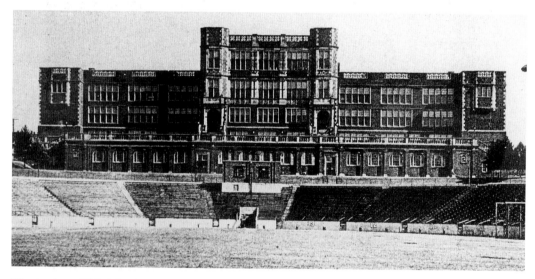

The Academy High School and Veterans Field, located between 26th and 28th Streets on State Street. The school is seen here in 1922, shortly after it was opened. The students attending the school completed much of the cabinet and woodwork in the building. (Nelson Archive Photo.)

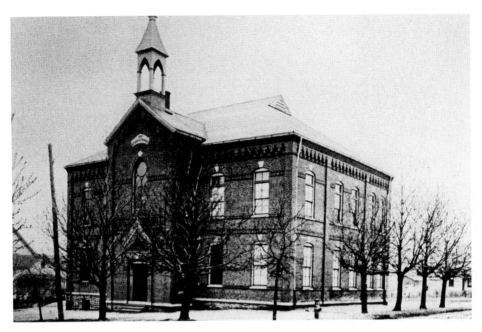

Saint John's Parish Parochial School at the corner of 27th and Wallace. At the time this 1895 photograph was taken, Saint John's Parish Parochial School was considered one of the best school buildings in Erie. (Nelson Collection.)

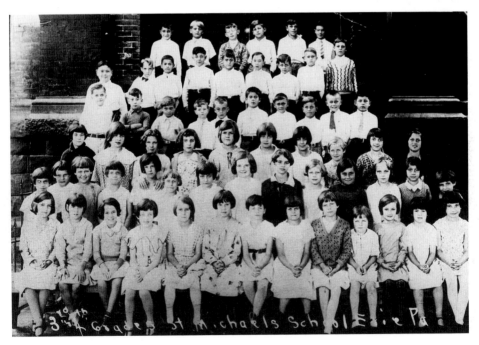

The third grade class of Saint Michael's parish school in 1935. The Roman Catholic Diocese of Erie operated excellent parish schools throughout the city. (Harry Nelson Photo.)

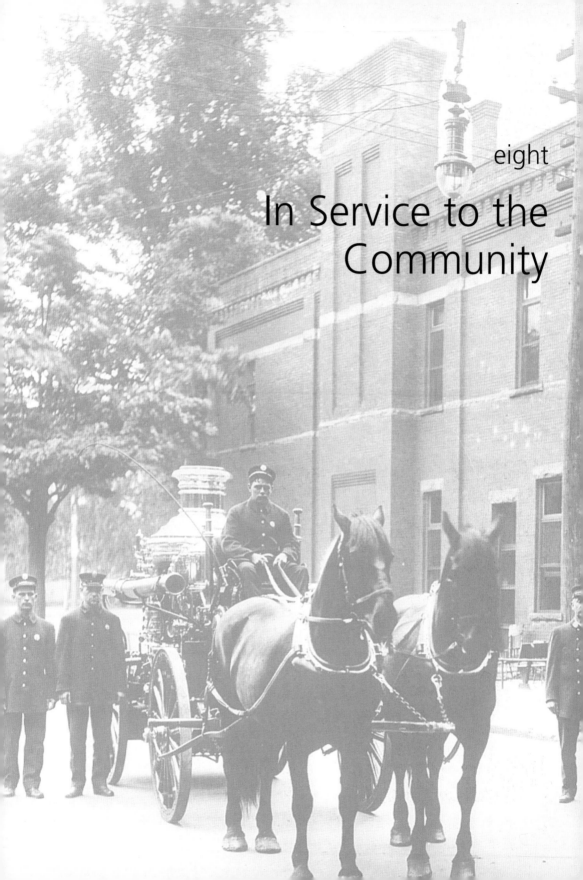

eight

In Service to the Community

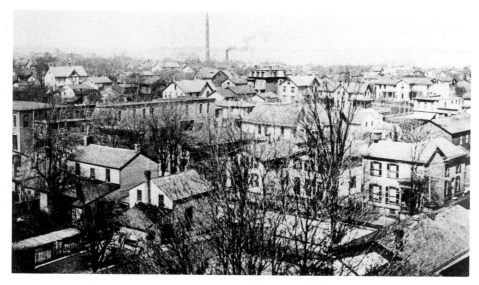

Looking over the peaceful city of Erie in 1887. The citizens of a community look to a small force of dedicated men and women to ensure the accustomed quality of life. These citizens are sometimes employees of the government, while others are simply public-spirited individuals. They make our city safe and insure that the public is served. We should always remember that peace is upheld by those in service to their community. (EHM&P Collection.)

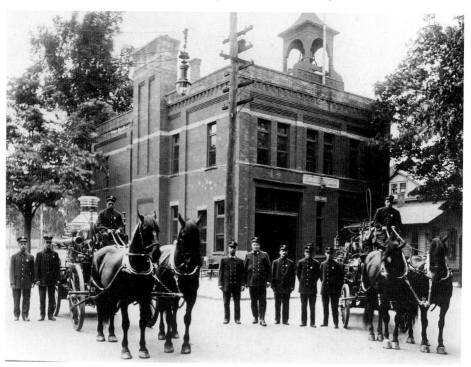

Engine Company Number 4, located at 5th and Chestnut in 1900. Erie went to the use of professionals in 1871. The need of the city had outgrown the volunteer system. Engine Company Number 4 is now home to the Firefighters Historical Museum. (Firefighters Historical Museum Archive.)

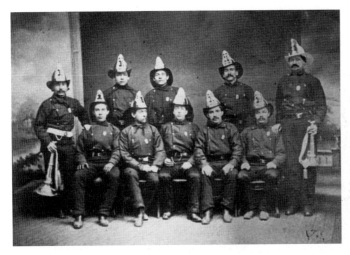
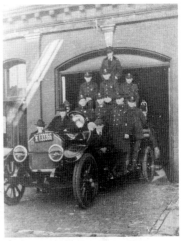

Above, left: A photograph taken in the late 1860s of the volunteer firemen of the city of Erie. This is believed to be Perry Engine Company 1 from East 5th Street. (EHM&P Collection.)

Above, right: Engine Company 2 on Parade Street. This 1913 photograph records the delivery of a new American La France combination. The second ward engine house was one of Erie's oldest stations. (Nelson Collection.)

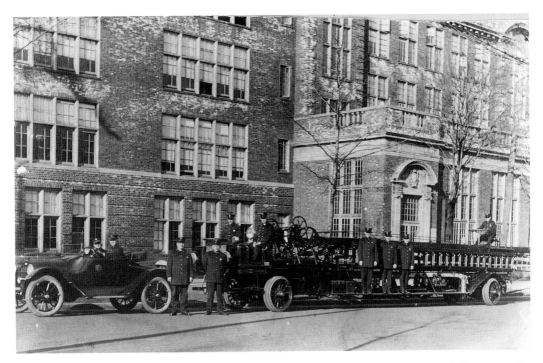

The men of Truck Company Number 1 and the chief of the Erie Fire Department with their state-of-the-art ladder truck at gridley Jr. High School. The Erie Fire Department has a proud history of service to our community. (Firefighters Historical Museum Archive.)

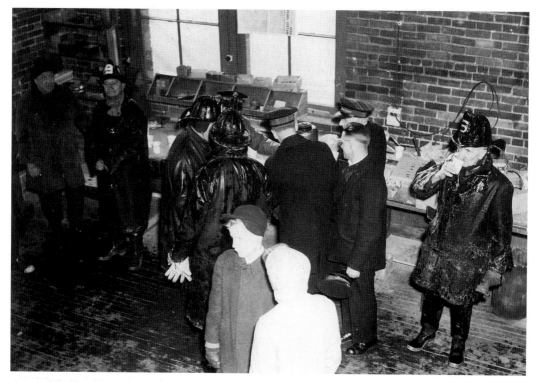

One of a number of Erie's dedicated public service organizations. The Salvation Army is seen here offering coffee to exhausted and frozen Erie firemen and citizens at a winter fire in Erie. (Nelson Photo Archives.)

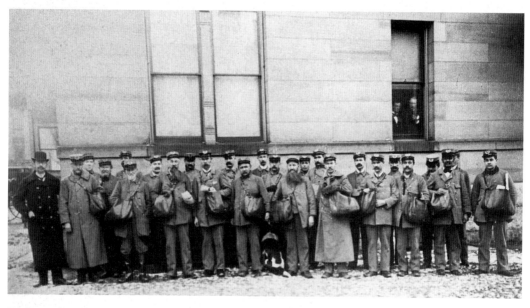

Erie's postal carriers outside of the main post office on South Park Row in the late 1890s. Since 1867, Erie has enjoyed regular free mail delivery through the city. In 1899 there were 41 carriers and 9 substitutes serving Erie. (EHM&P Collection.)

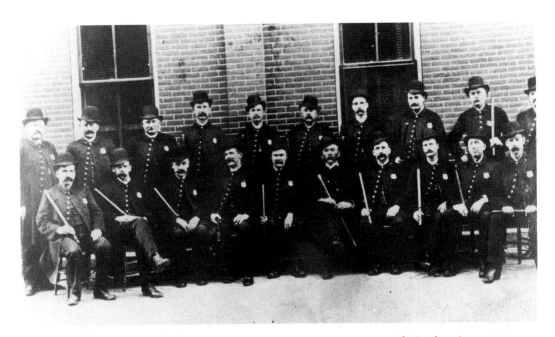

The Erie Police Department in 1900. The police department began its professional service to our community in 1855 with only three officers. The continued growth of our city required a larger force of police officers. (Joe Weindorf Collection.)

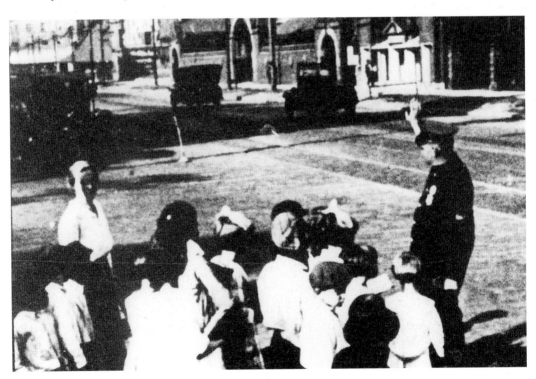

An Erie police officer stopping traffic on a busy Erie Street, insuring the safety of our children. (Nelson Collection.)

Erie police officer Rufus D.H. Baxter in the radio room at police headquarters in the late 1930s. Mr. Baxter was Erie's first African-American police officer. He entered the police force in 1913, and served with honor and distinction for over 30 years. (Joe Weindorf Collection.)

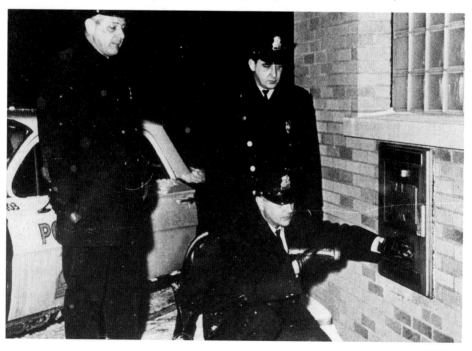

Erie Police Officers Pat Lillis and Joe Linzdowski during a criminal investigation. (Joe Weindorf Collection.)

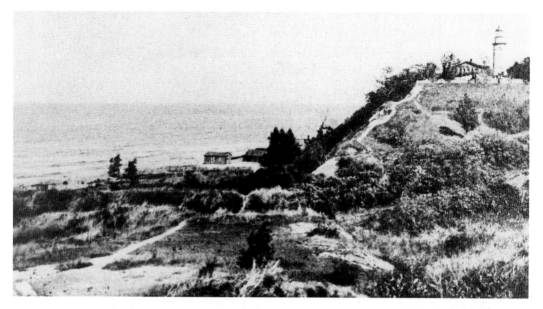

The Land Lighthouse in the 1880s. Erie is an important port on Lake Erie. As such, the safety of shipping was early on a concern for our community. The Land Lighthouse at the foot of Dunn Boulevard went into service in 1818. It was the first light house on the Great Lakes, and it served until 1899. (Nelson Archives Collection.)

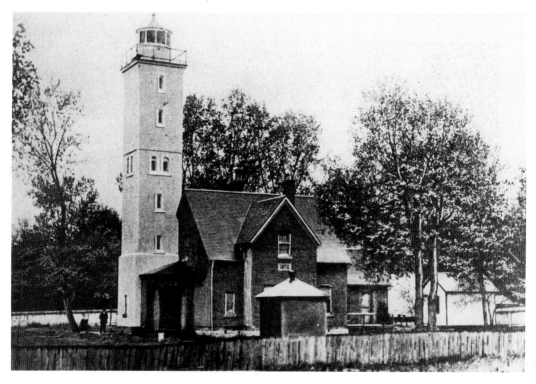

The Presque Isle Light Station shortly after its construction in 1872. This is one of the better known structures in Erie. (Nelson Archive Collection.)

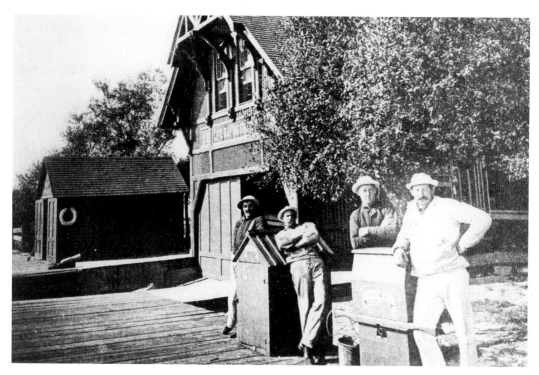

The United States Life Saving Service at Erie. The station was founded in 1876 to rescue lake mariners from ships in distress. Captain Andrew P. Janson and some of his men are pictured here in front of the station in the 1890s. (Nelson Archive.)

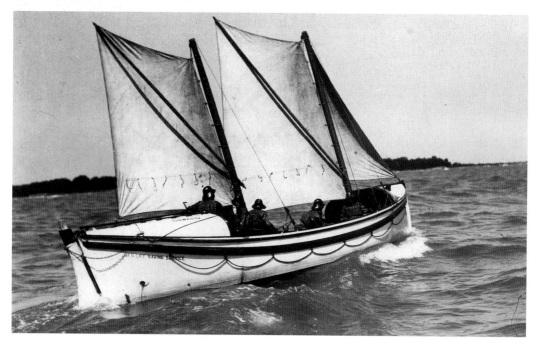

The rescue launch *Onward* heading for the channel on its way to a mission on the lake. (Nelson Archive.)

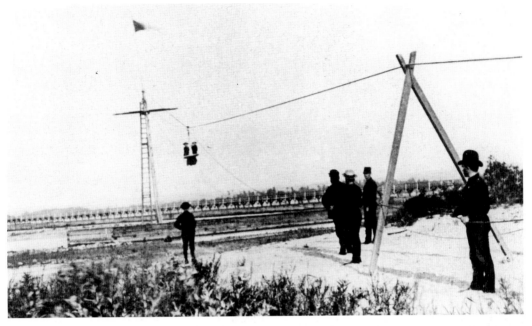

Captain Douglas Ottinger's life car, used to rescue crew and passengers from stranded ships. It is seen here during a life-saving drill across the Erie channel in the late 1890s. (Joe Weindorf Collection.)

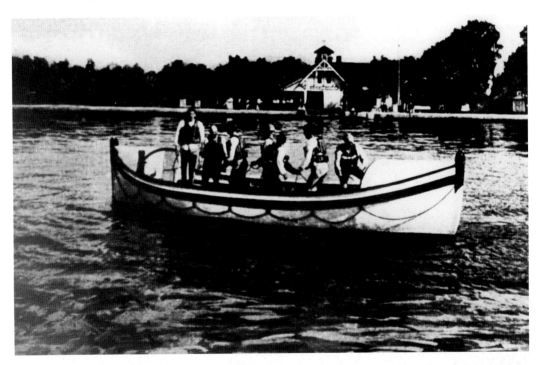

The United States Life Saving Service. The LifeSaving Service came to Erie in 1876 and was an important part of our harbor's operation in days gone by. Today the men and women of Erie's U.S. Coast Guard Station carry on the fine tradition of the Life Saving Service.

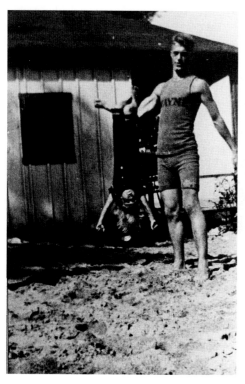

Left: The beautiful sandy beaches of Presque Isle, located across the harbor from Erie. This has always been a place of recreation for Erieites. Many young Erie men became life guards at Presque Isle. Here is one showing off for the camera in 1930. (Jim Zollner Family.)

Below: The stone jetty life guard's chair on a beautiful Erie day in the late 1930s. The young life guards can be seen relaxing at the base of the chair. (Joe Weindorf Collection.)

Opposite, above: The Erie Water Department Chestnut Street pumping station as seen from the bay in 1890. The most remarkable feature of our early water system was the 265-foot-tall brick stand pipe. In 1873 it was the largest brick structure in the world.

Opposite, below: The latest in service equipment, *c.* 1920. Since 1868 Erie has been served by the dedicated men and women of the water department. The system has been expanded, though sometimes with great political tribulations, and improved to provide Erie with safe water. (Nelson Archive Photo.)

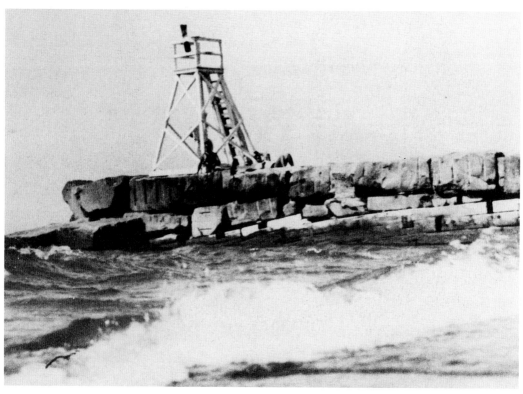

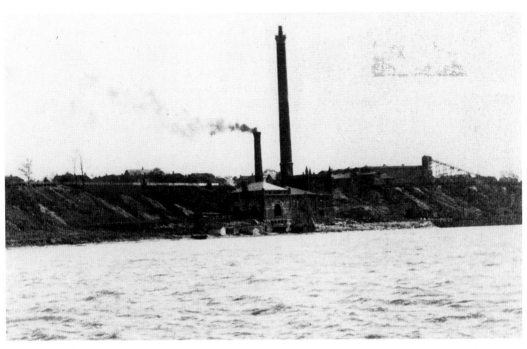

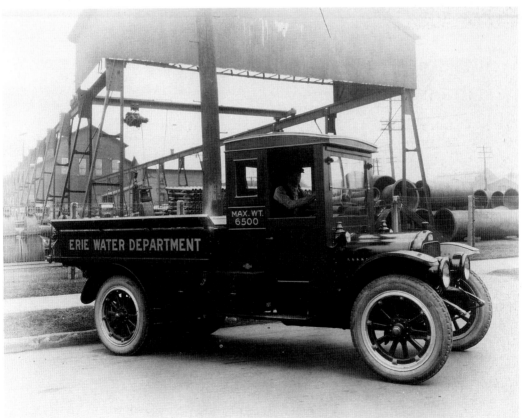

The Erie Car Works Limited, located at 16th and Cascade. This company was formed after fire destroyed the original Erie Car Works in 1894. The firm built railroad rolling stock and could produce 16 cars a day in 1900. (Laurie McCarthy Family Photo.)

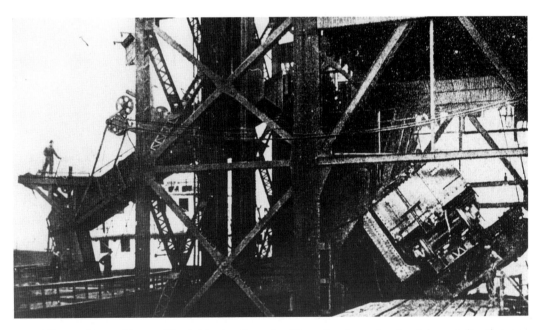

The massive machinery of Dock Number 2, used to lift a railroad car of coal and dump it directly into ship's holds in 1900. The harbor at Erie was the first area of our city given to industrial development on a large scale.

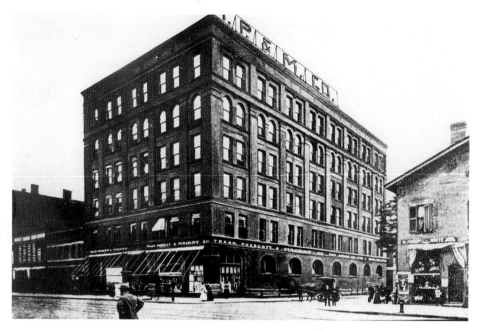

Trask, Prescott & McCray of State Street, *c.* 1870s. Though Erie was home to many heavy industrial establishments, there was another sector of commerce in Erie. Trask, Prescott & McCray eventually became Trask, Prescott & Richardson, Erie's first large dry good establishment.

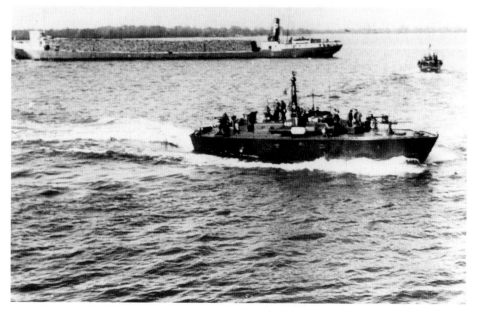

Perry Ship Yards. Building ships enabled our city to gain some degree of historic acclaim. Perry's battle fleet was constructed in Erie and the iron warship *Michigan* was assembled here. During World War II the U.S. Navy turned to Perry Ship Yards to produce motor torpedo boats. (Robert Nelson Photo.)

ten

The Waterfront
of Erie

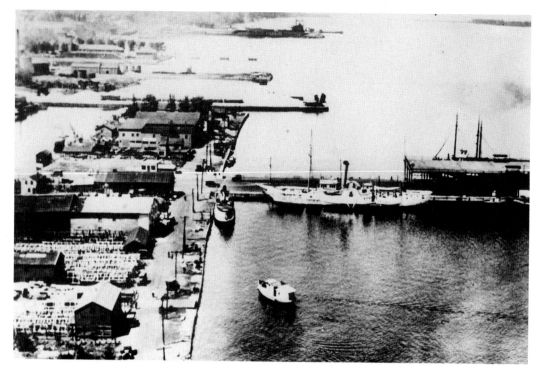

A photograph, taken by Harry Nelson in 1928 from the top of the Pennsylvania Elevators, looking west along the south shore. The harbor has been our city's most influential feature, impacting the past, present, and future development of our city. It has been the stage for events in American history and a hub for Great Lakes shipping. The USS *Michigan* is in the foreground of the image. Erie's docks and piers stretch out along the bay. (Nelson Photo Collection.)

The harbor at Erie in 1900. The harbor was originally entered through a channel at the head (or western end) of the bay. Between 1835 and 1896 the east channel was dredged and cleared. (Nelson Archives.)

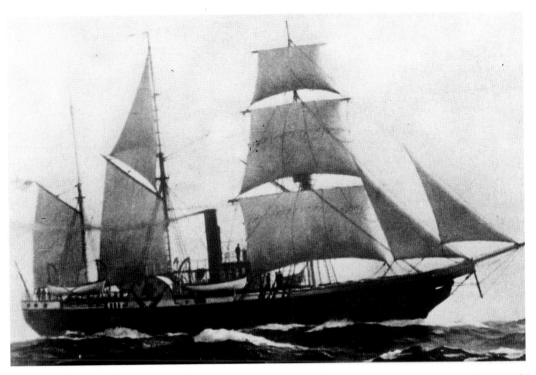

The USS *Michigan* in the 1870s. Erie's harbor was the home port of the first iron warship in the United States Navy. Known as the *Michigan* (or the *Wolverine* in later years), she was launched at Erie in 1844 and cut up for scrap during World War II. (Nelson Archives.)

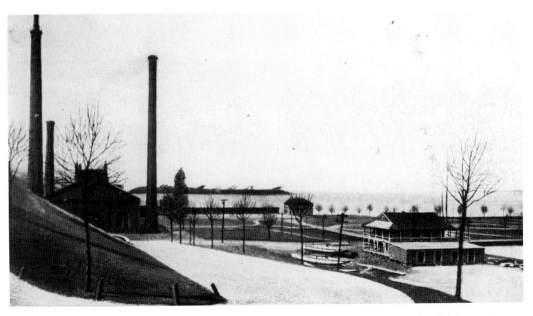

The landscaped grounds of the Chestnut Street pumping station and the Erie Yacht Club house. In this 1890s photograph we can see the pride our citizens have for their city. (Nelson Collection.)

The Pennsylvania State Commission of Fisheries hatchery at 2nd and Sassafras Streets. In an attempt to increase the number of fish in Lake Erie, this hatchery was built in 1885. (Nelson Archive Photo.)

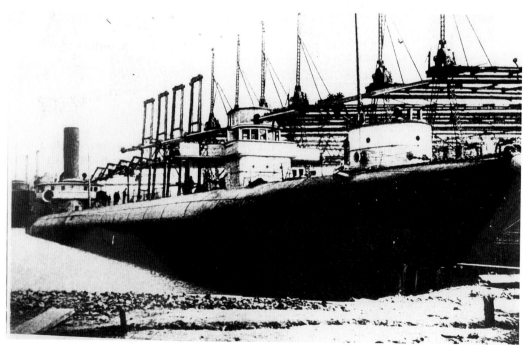

A whale-backed freighter berthed at the Erie ore dock around 1900. This uncommon style of ship was a common visitor to our port. (EHM&P Collection.)

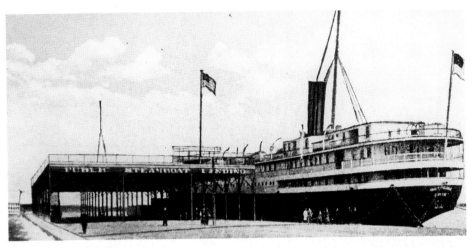

Erie's principal steamboat landing at the foot of State Street, home port to over 90 vessels in 1907. The ship tied to the east end of the landing is thought to be Edward Mehl's steamer *Uganda*. (EHM&P Collection.)

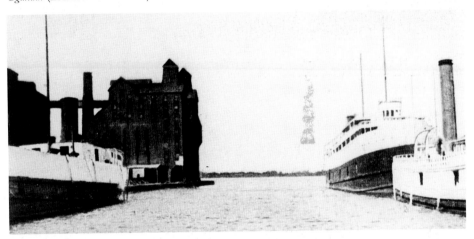

The Anchor Line Dock and Erie Western Transportation grain elevator located at the foot of Holland Street. These elevators were destroyed by fire on December 10 and 11, 1915. (EHM&P Collection.)

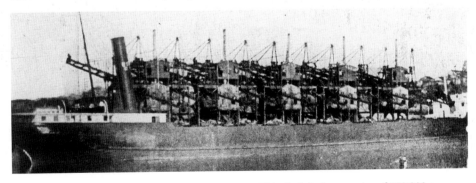

The Erie and Pittsburgh coal dock in the late 1890s. This dock had a capacity of 600,000 tons. (EHM&P Collection.)

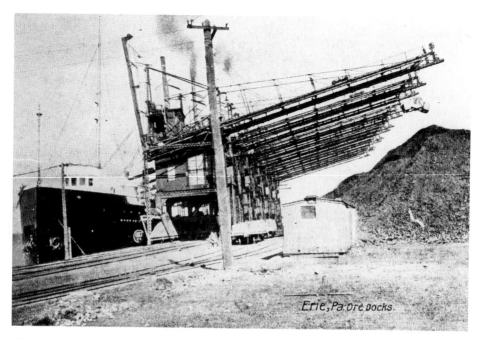

The iron ore dock number 4 of the Carnegie Steel Company in the early 1900s. This dock was operated by Pickands Mather & Co. of Cleveland, Ohio. (Nelson Collection.)

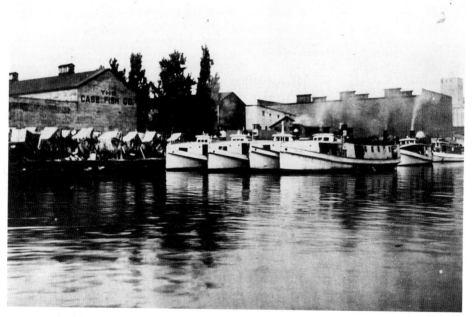

The wharf and fleet of the Case Fishing Company in 1907. There were once over 54 fishing boats operating out of Erie, but the industry eventually failed due to over fishing. (Harry Nelson Photo.)

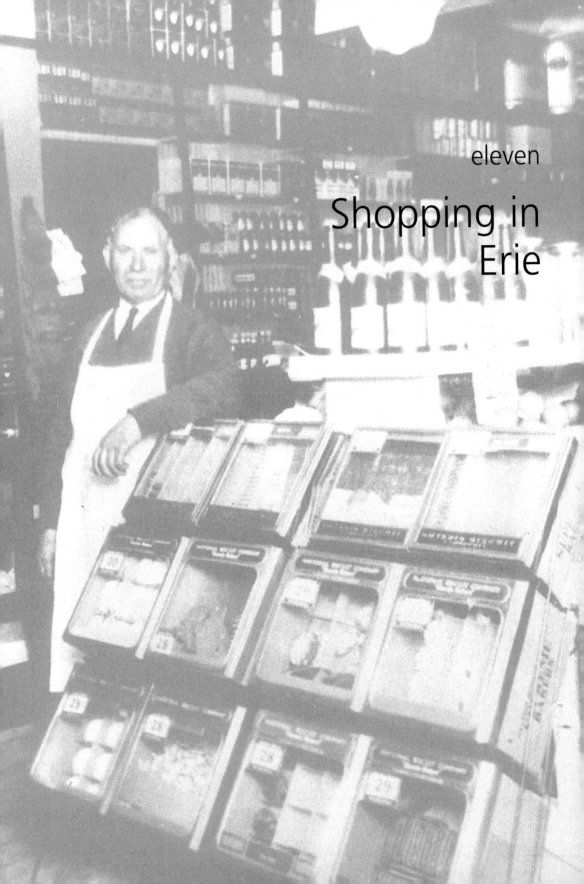

eleven

Shopping in Erie

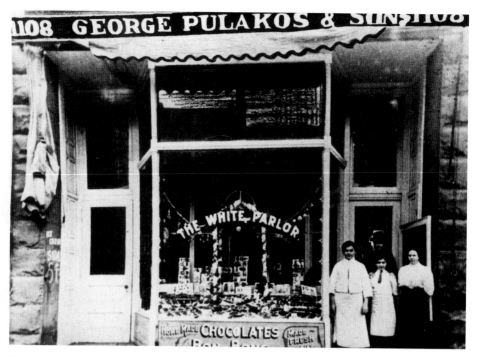

George Pulakos and his family in front of their store on State Street. In the days before large suburban shopping centers and automobiles, Erieites would go shopping downtown. It was a short trip from your neighborhood to the center city by trolley. The merchants of Erie were ready to provide us with all our requirements and they knew us by name. The George Pulakos Confectionery Store was a favorite stopping place for young and old.

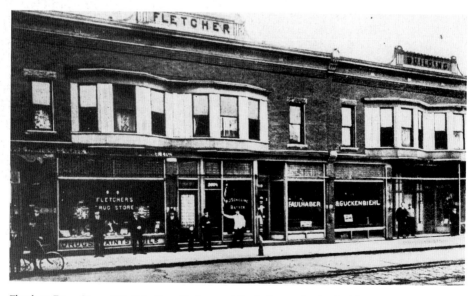

Fletchers Drug Store, H.J. Schelling, Barber, and Faulhaber & Guckenbiehl, located at 364 West 18th Street. The proud merchants posed in front of their businesses for this 1900 photograph. (Nelson Archives.)

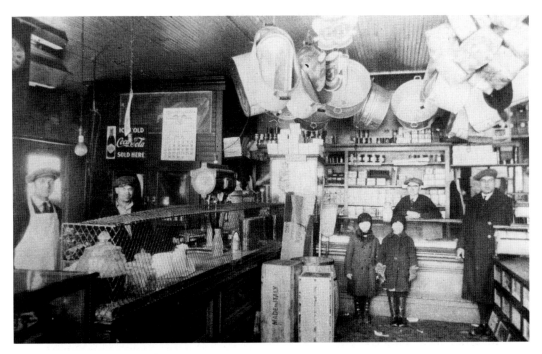

The interior of the B. Grande General Store (see p. 115) at the corner of West 16th and Cherry Streets. (see p. 115) This neighborhood grocer and general mercantile business was just one of many small neighborhood stores serving Erie. (Paul Morabito Collection.)

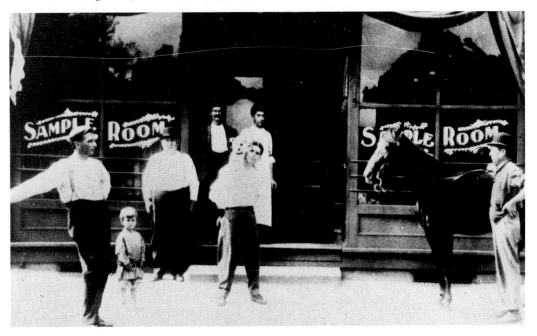

The sample room of Emandus Hersperger at 708 West 18th Street. Emandus is standing with his horse to the right of this photograph, which was taken around 1900. (Schwab Family Photo.)

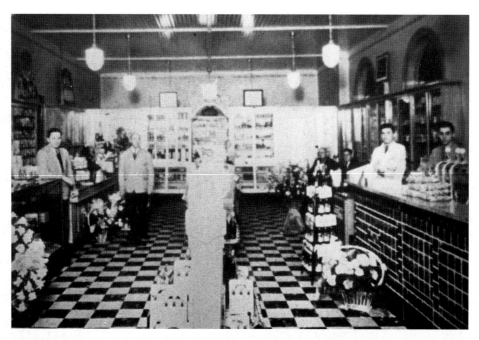

The Colonial Drug Store at 524 West 18th—a favorite pharmacy in the Little Italy neighborhood. Mr. Santomenna and his staff were able serve customers here in the language of their native land. (Paul Morabito Collection.)

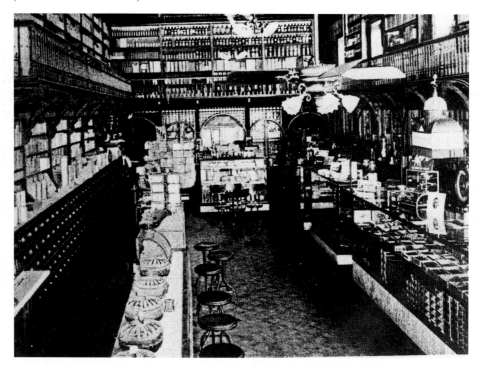

Frank L. Feisler's Pharmacy at 1002 State Street. This is a good example of the many well-appointed stores located in downtown Erie around 1900. (EHM&P Collection.)

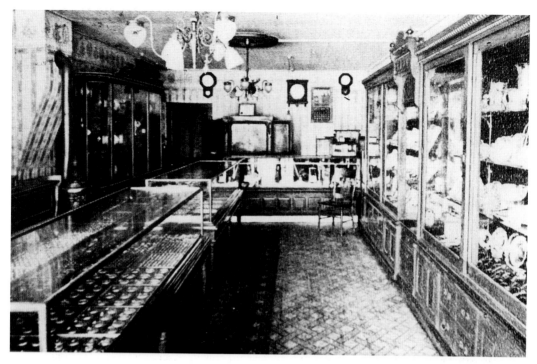

The B.F. Sieger Jewelry Store on Turnpike Street in 1900. Sieger's, Erie's oldest jeweler, first opened in 1865. He also made surgical instruments for doctors. (EHM&P Collection.)

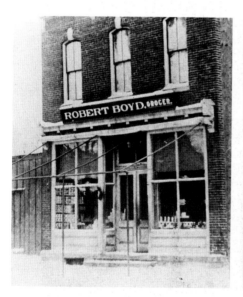

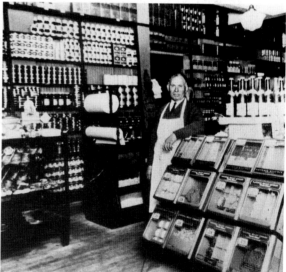

Above, left: The Robert Boyd Grocery Store located at 4th and Chestnut Streets. This store served Erie's lower west-side neighborhood. (Joe Weindorf Collection.)

Above, right: Mr. Grande's grocery store in 1924. Note the many changes that have taken place since the 1900s (see p. 113). This store was one of the many small family stores serving Erie. (Jimmy & Alfred Iesue Collection.)